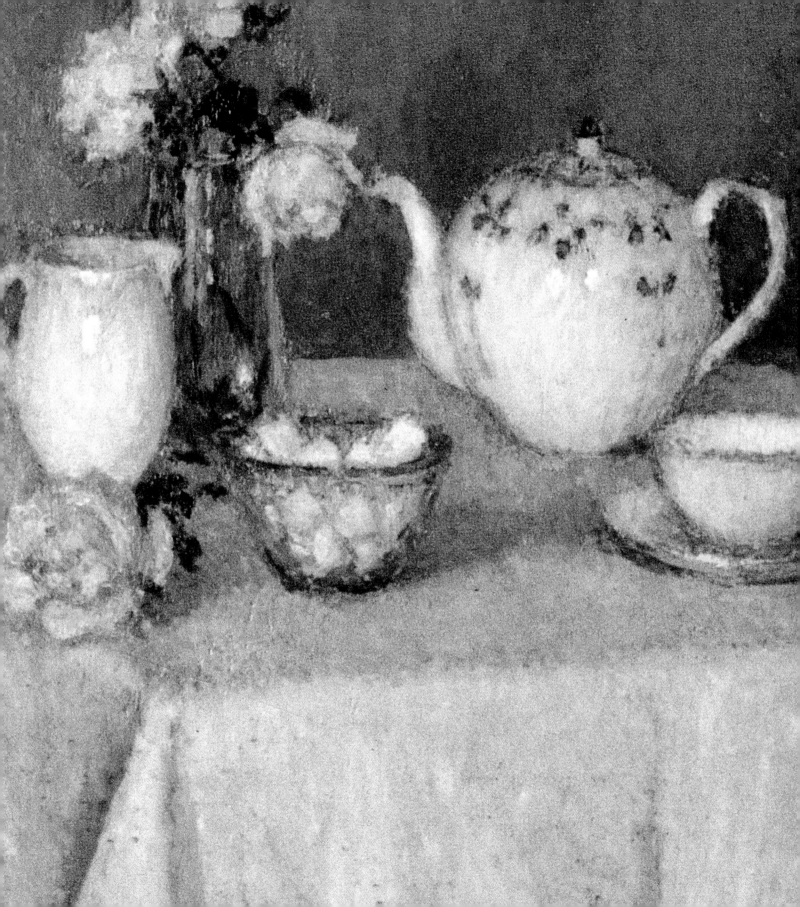

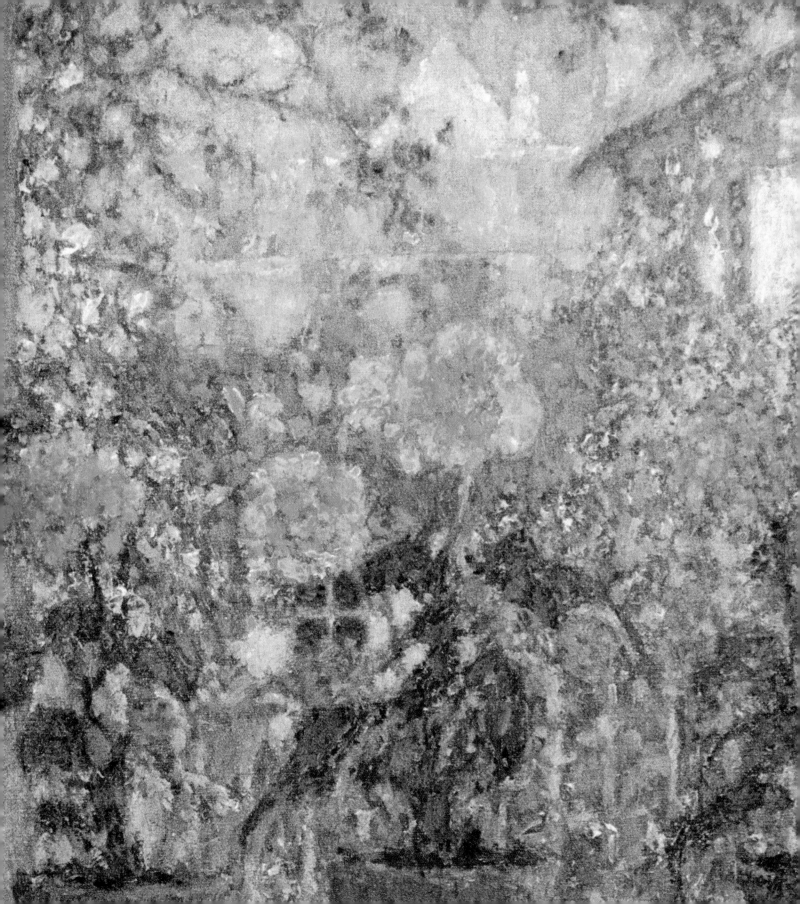

thank you for your Hospitality

TEXT BY WELLERAN POLTARNEES

PAINTINGS BY HENRI LE SIDANER

LAUGHING ELEPHANT MMV

ISBN 1-59583-006-5

LAUGHING ELEPHANT

3645 INTERLAKE AVENUE NORTH SEATTLE WASHINGTON 98103

WWW.LAUGHINGELEPHANT.COM

All of the illustrations in this book are paintings by the French painter Henri Le Sidaner (1862-1939). There are several reasons that I have chosen to illustrate this book about hospitality entirely with his pictures. First, his vision of a home as a lovely place aside from the world's tumult, where one can enjoy peace and beauty, is remarkable and consistent. Second, the unpeopled rooms invite us to step into this glowing world. Third, Le Sidaner's work is too little seen and appreciated.

I hope this work will please many who are grateful for having been allowed to share others' homes, and that it will prove a welcome gift for those who have generously opened their doors.

WELLERAN POLTARNEES

Thank you
for the invitation
to your home,

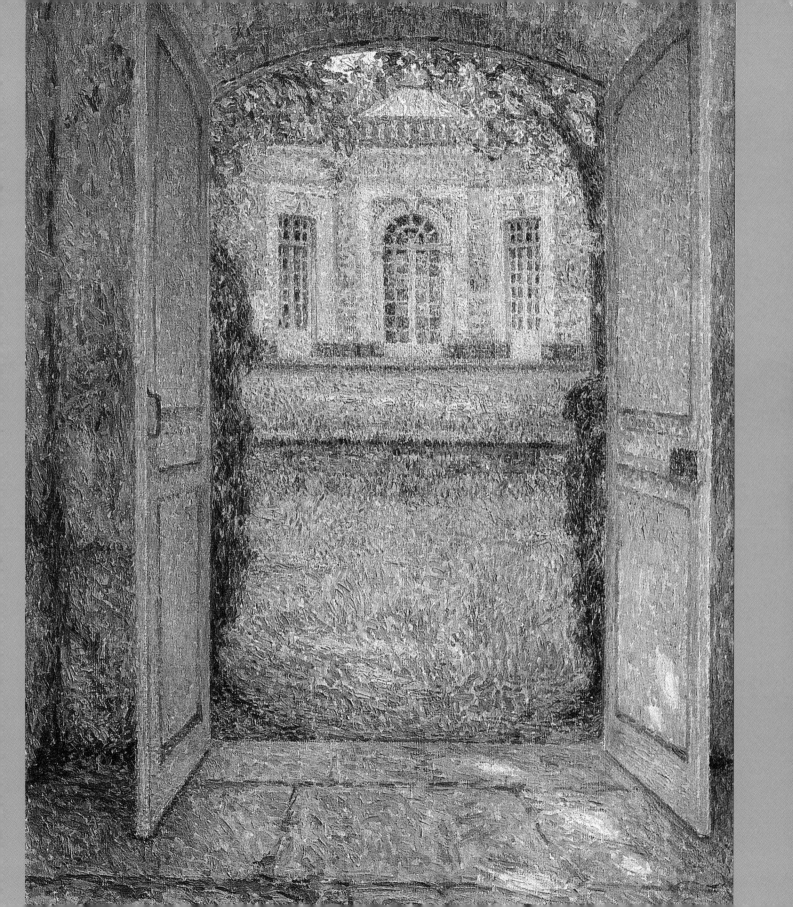

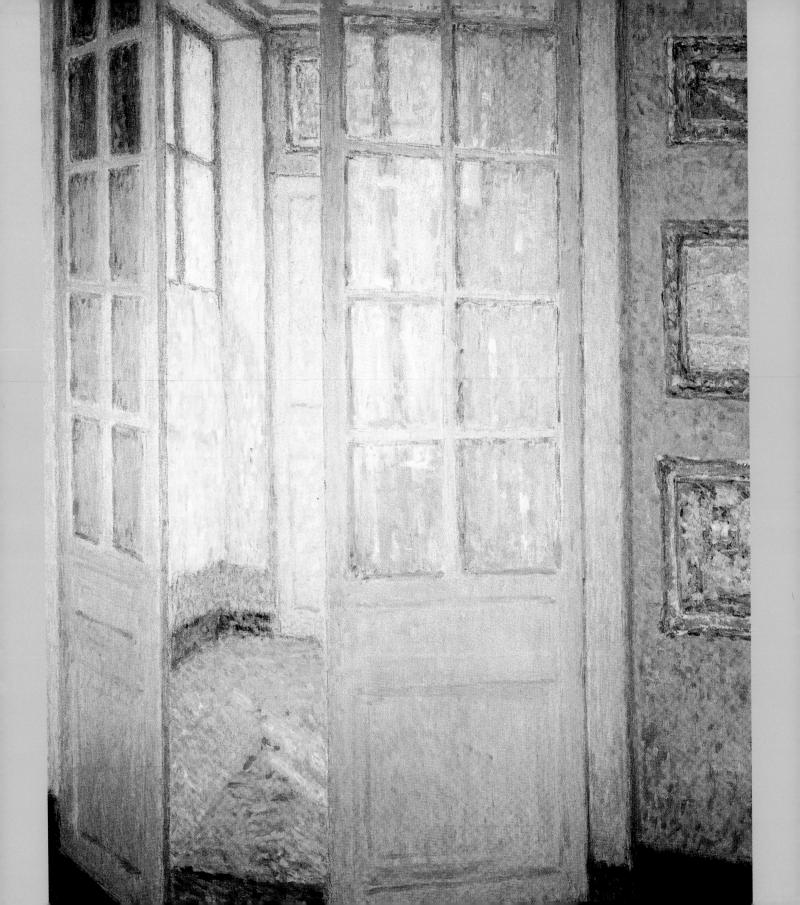

and for the warm reception,

the relaxed

atmosphere,

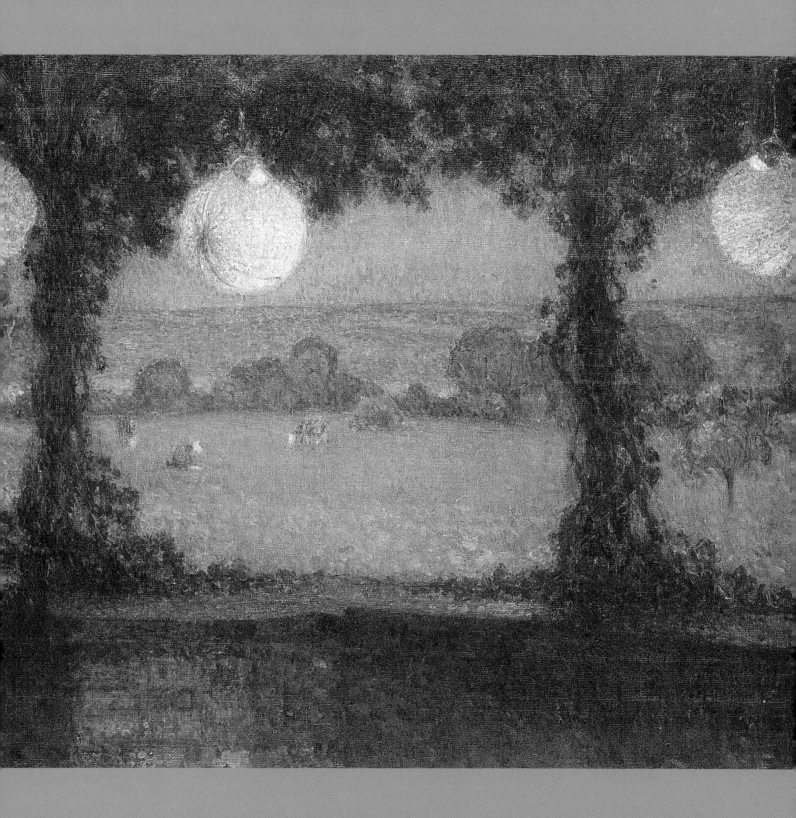

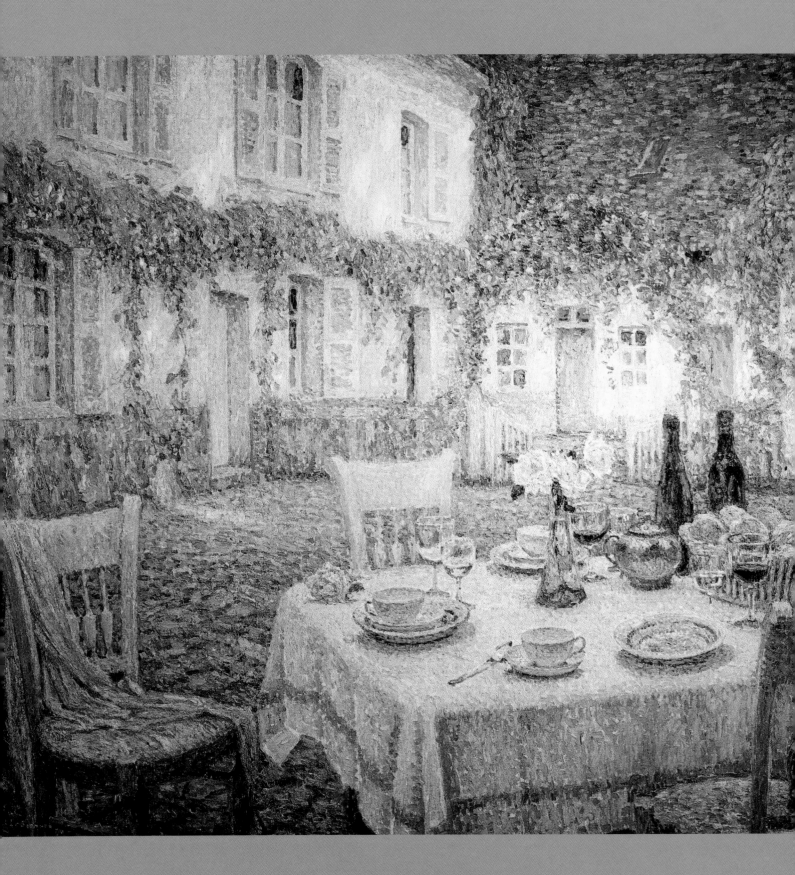

the good conversation,

the small acts

of thoughtfulness,

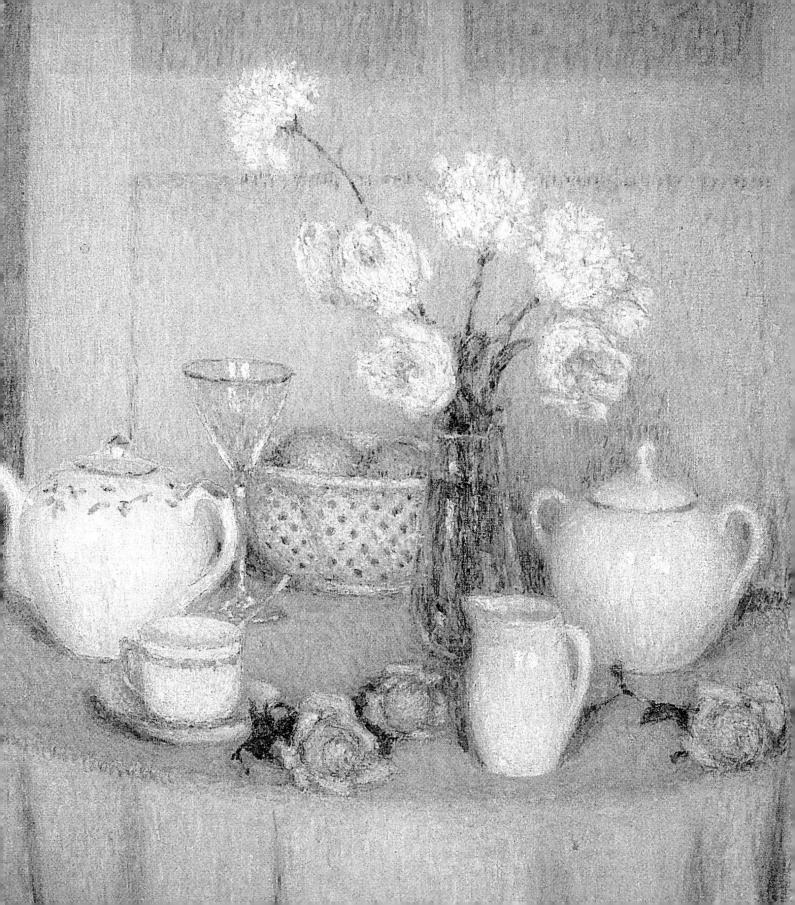

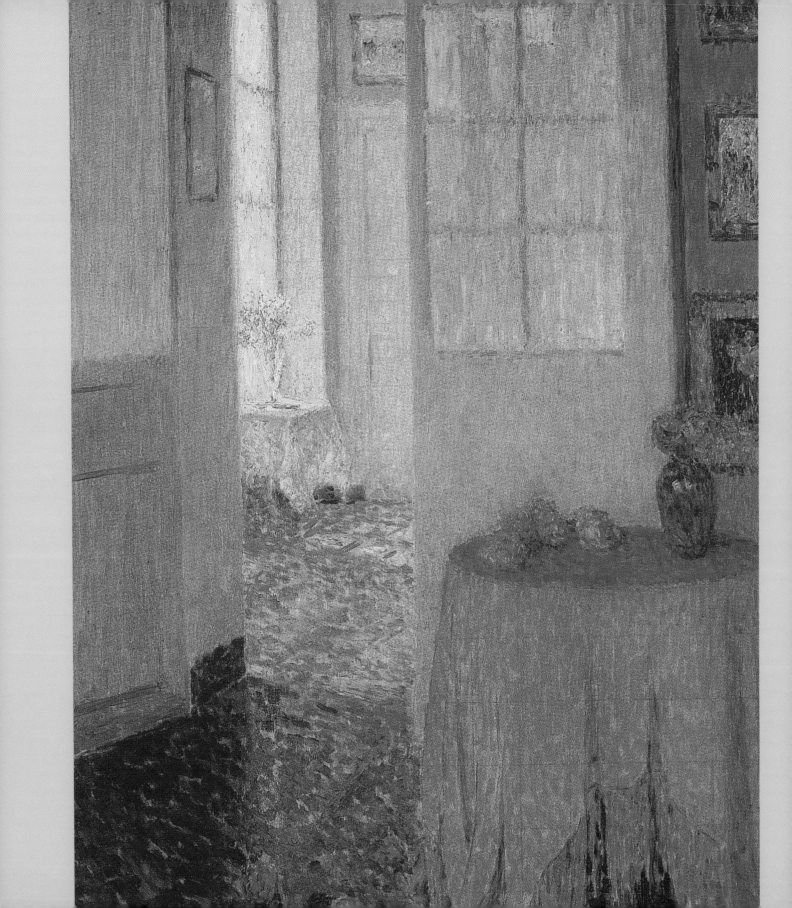

the many

interesting things to see,

the lovely refreshments,

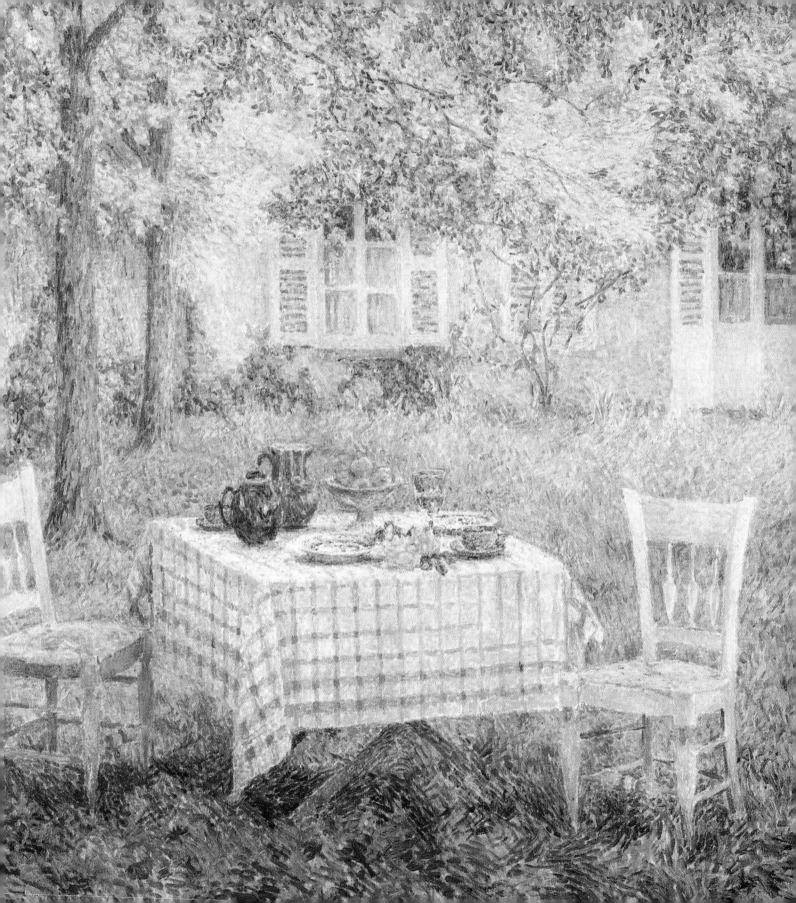

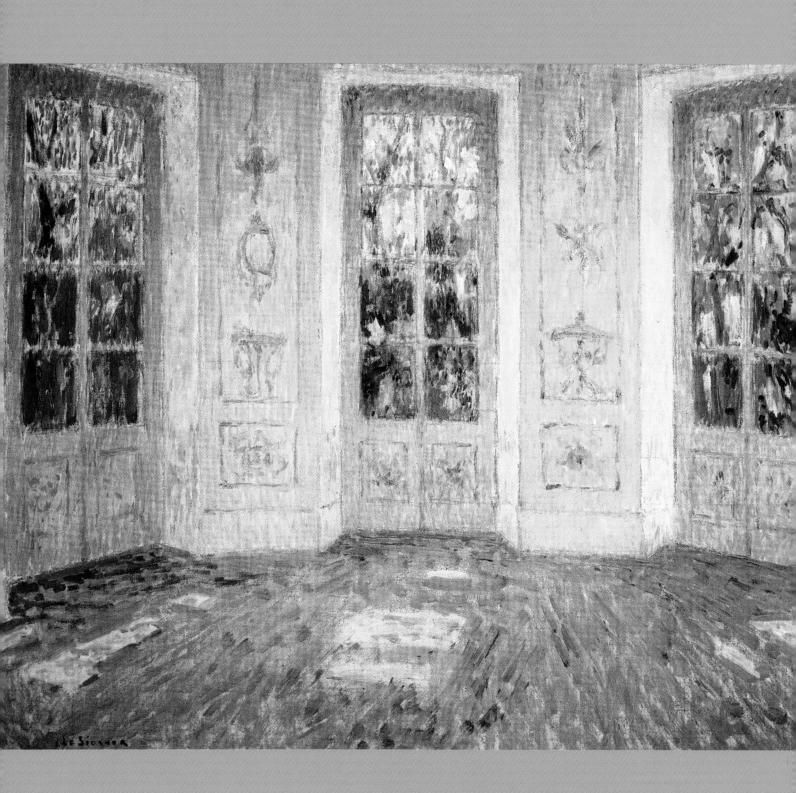

the personality

of the rooms,

the shared laughter,

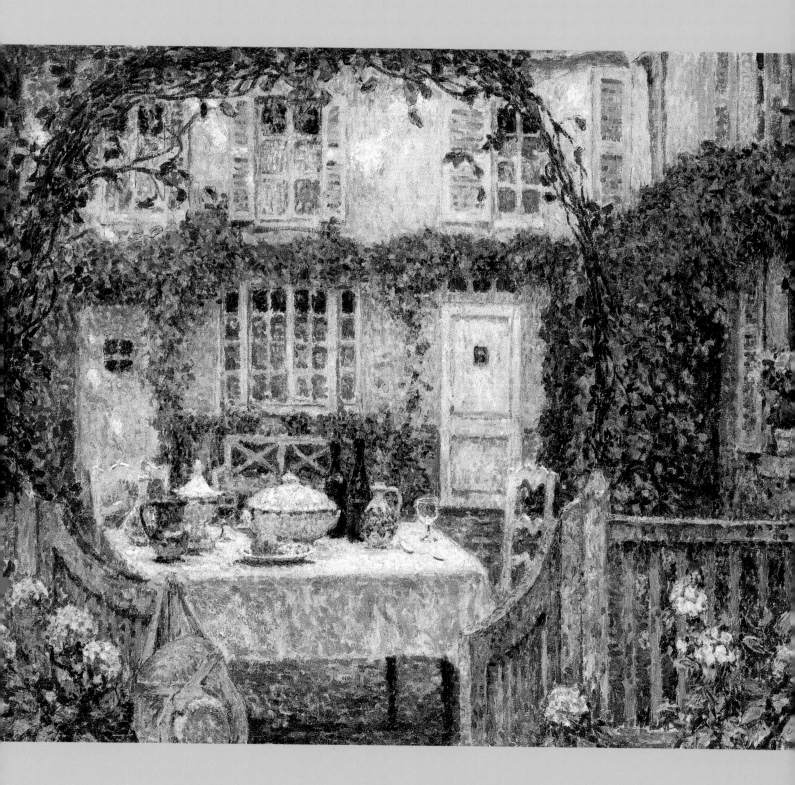

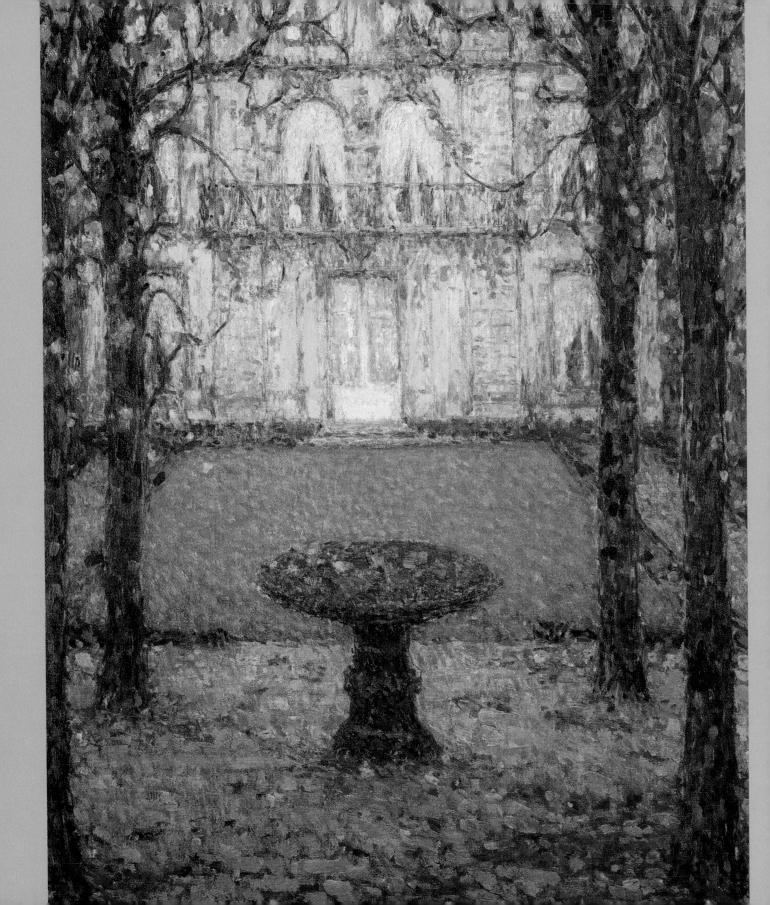

the sense of peace,

and the effort you put
into the preparations.

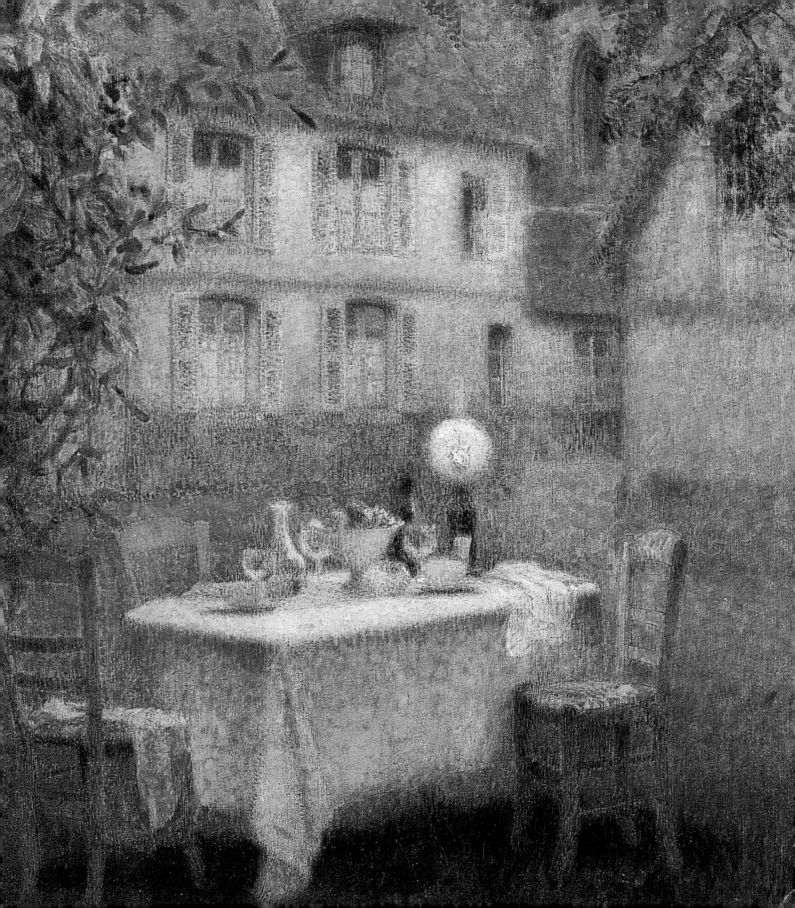

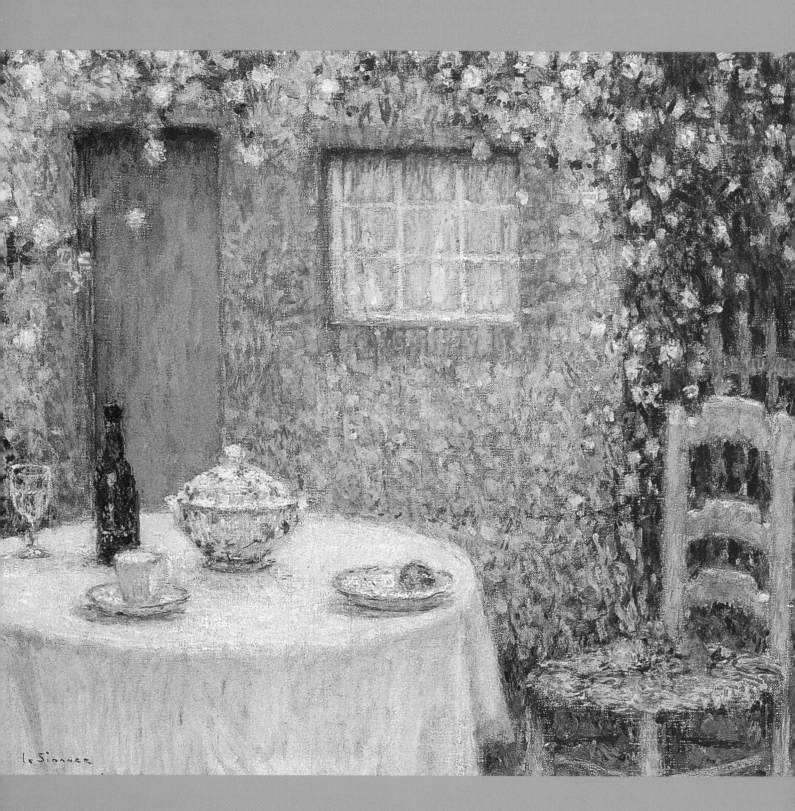

Thank you for your willingness to open your home and your heart.

COLOPHON

DESIGNED AT BLUE LANTERN STUDIO
BY SACHEVERELL DARLING & STEVEN A. ROSSAN

TYPESET IN BICKHAM SCRIPT AND GARAMOND

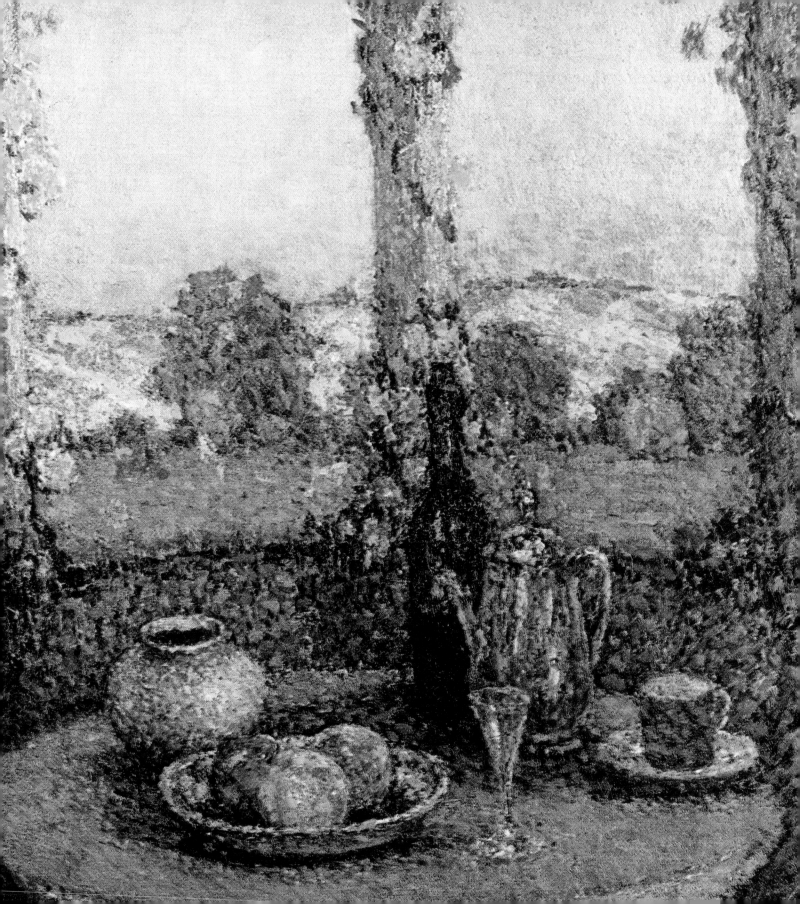